Trailers

**University Press of Virginia**  Charlottesville and London

# Trailers

Photographs by Carol Burch-Brown     Text by David Rigsbee

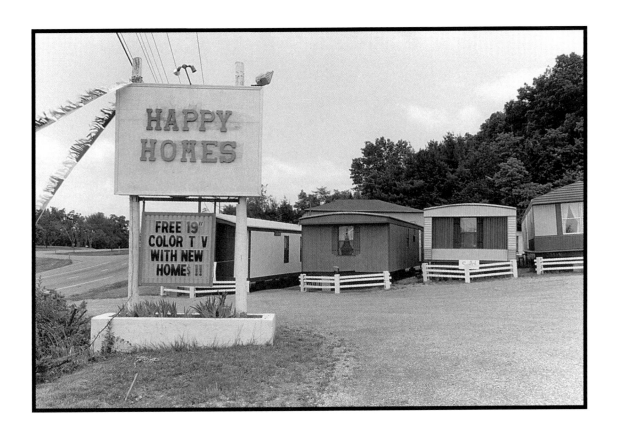

Mississippi State University

Publication of this book was assisted by a grant from the
Virginia Polytechnic Institute and State University.

The University Press of Virginia
© 1996 by the Rector and Visitors of the University of Virginia

*First published 1996*

♾ The paper used in this publication meets the minimum
requirements of the American National Standard for
Information Sciences—Permanence of Paper for Printed
Library Materials, ANSI Z39.48-1984.

Library of Congress Cataloging-in-Publication Data
Burch-Brown, Carol.
Trailers / photographs by Carol Burch-Brown ; text by David
Rigsbee.
p.   cm.
ISBN 0-8139-1680-1 (paper : alk. paper)
1. Mobile homes—Virginia—Montgomery County—Pictorial
works.
2. Mobile home living—Virginia—Montgomery County—
Pictorial works.
I. Rigsbee, David.  II. Title.
TX1107.2.V8B87   1996
643'.2—dc20                                           96-6014
                                                        CIP

Printed in the United States of America

to Joanna Burch Brown

and Earl Rigsbee

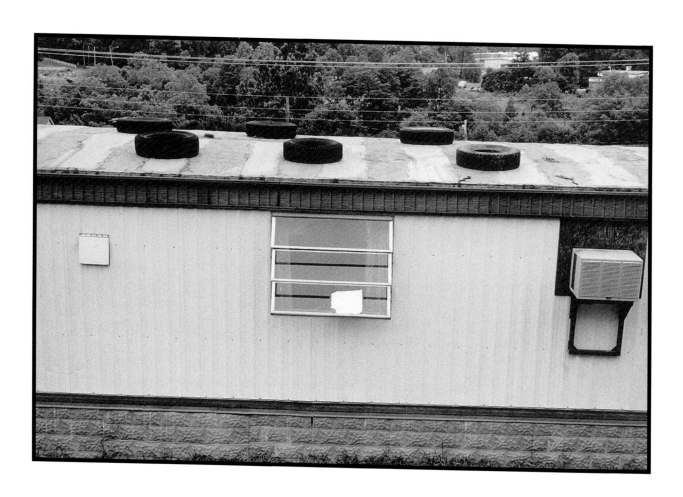

This project developed gradually over a period of ten years, after an unplanned photographic foray one afternoon into a sprawling, low-income trailer park that used to be in the middle of my hometown of Blacksburg, Virginia. The park had been there about forty years, across the street from the main cemetery and only a few blocks away from the university campus of Virginia Tech. From the cemetery the view outward was of the trailers, and from the perimeter of the trailer park one mostly saw the cemetery. Separating the two was a busy road that curved outward from downtown and extended into the beautiful Appalachian countryside. Along that picturesque road are old log houses, shacks, and other iconic dwellings of the southern mountains, as well as many more trailers in the mix of rural and suburban housing.

What drew me to the trailer park in town and later to trailers in the countryside was both curiosity about who lived there and also what I came to think of ironically as a failure of the "Family of Man response." In contrast to decaying but aesthetically appealing Appalachian shacks and cabins, trailers have little emotional currency as

emblems of a struggling but noble humanity, especially among professional people. Their campiness is oddly resistant to nostalgic idealization. Although trailers are ubiquitous in our communities and countryside, they do not appear in our iconography of tastefully worn dwellings and colorful subcultures, except as a sign of otherness. Instead, they frequently provoke annoyance, followed by dismissal, often in the form of eventual rezoning banishing them to the outskirts of town. This banishment involves a quasi-moralized judgment about what is "good" for the community—an unacknowledged conflation of standards of aesthetic taste with civic goodness. A poor dwelling that is considered both ugly and easy to get rid of is not a safe place to live.

And yet trailers are such condensed and bluntly practical dwellings that they also convey strong subliminal messages about shelter and protection to passersby, even those irritated by their sudden appearance along a country road or on a nearby street. The trailer embodies the magic possibility of a home space so rooted to the individual that it can be moved at will and need never be left behind. Many of the people whose trailers I photographed had developed an artistry around personal containment. Their penchant for arrangement

was shaped over time by the exigencies of the trailer's limited but oddly independent space. Something clever is achievable in such a provisional frame that is usually elusive in any other American dwelling: a form of bodily improvisation, a calling-attention-away from too obvious limitations, an assertion not of ego but of self in every nook and cranny.

It is a common joke in our region that the best views of the mountains are from trailers. Many people of means buy country property not with the intention of building a permanent house on a foundation, but of moving a trailer or mobile home onto it. Gradually, porches and back rooms are added until often the original outline of the trailer is something felt rather than seen. It is not unusual for two families to purchase a plot of land together and live in trailers in close proximity. For many years in the rural South a tradition held that when a family attained enough economic means to build a new house the old one—usually further back on the property—would become home for newly married children or for elderly relatives. More often now the practice is to move a trailer behind the main house for a grown child or grandparent. These small spaces carry over the intentionality and memory of the larger family and the larger house.

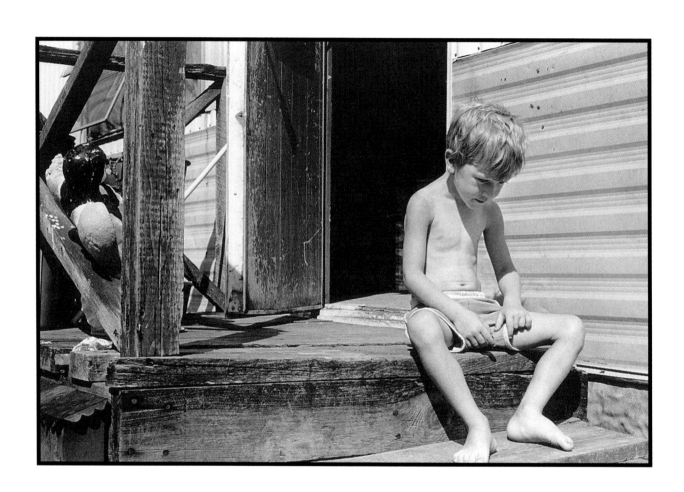

All of the people and all the trailers in the photographs were once located within a ten-mile radius in Montgomery County, Virginia, at about ten different locations including the trailer park in the middle of town. By the late 1980s most of the people had moved on, though usually without their trailers because the trailer parks had been supplanted by development projects of one kind or another. In several cases, families had to buy their trailers from the landowner or the previous tenant and lease the patch of land on which the trailer stood. Not uncommon, such an arrangement releases the landowner from responsibility for moving or maintaining the trailer. At the "right" moment for developing the property, tenants may not be able to afford to relocate their trailers and in some cases the trailers themselves are in no condition to withstand a move. The people who lived there, already mostly out of view, simply disappear altogether and their financial investment evaporates. This was the fate of the trailer park in the middle of my town, where the woman in the Elvis Presley photograph lived.

Not long after I took these photographs, the trailers were eradicated, replaced by apartment buildings and a more prosperous clientele.

The ease with which the trailers and people disappear unsettles me. Nothing about trailers is fixed, and yet everything is overdetermined; they are seemingly intractable and yet vaporous. Normally, the passage of time renders change in a neighborhood. But here, the default is for the sudden scattering of the neighbors themselves. No amount of capturing particular events or moments photographically has had even the slightest impact on the disappearance of the trailers.

Eventually, my photographs became a meditation on taste and its slippery grasping after emotional identity. I have memories, too, that are not in the photographs: A father holds his baby under a scene of the Last Supper; his kitchen is filled with the dialysis equipment necessary to keep him alive. An elderly couple seated beneath hunting trophies recount the story of their four children who had polio. An old, disabled black woman has had her two white "baby dolls" with her for twenty-two years. She first lived in the trailer with a mentally retarded white man. One day she found him dead on the sofa; she shows me the picture. An old man with his fly open brandishes a paring knife at the boys who taunt him every day; he chases them around his trailer. Unaware of me, a taciturn husband humps his young wife on the living

room sofa, the front door of the trailer wide open. The woman with an Elvis Presley lamp shows me her Elvis memorabilia, three hundred key chains, forty Avon bottles, and a large doll collection. Every time I see her she has rearranged them. A couple say that what they would really like is to move—into a "double-wide."

In the photographs the space of the trailer imbues things of personal significance with a special intensity. David Rigsbee's text contemplates both the photographs and his own family's quietly bizarre trailer history. While the photographs often register specific boundaries and limiting edges, the text ranges further down the highway. Thus, the images and text comprise two different narrative voices within the book, distinct but connected—as if my trailer is temporarily located and David's is in perpetual transition. Our advice is to read for the conversation rather than to look for a unified field of story-verified-by-illustration.

David Rigsbee and I would like to express our deep appreciation to the people of Montgomery County who participated in this project and who appear in our photographs and stories. We are also especially

grateful to Frank Burch Brown, Nikki Giovanni, Elizabeth Fine, Ann Kilkelly, and Charles Hart for their practical help, encouragement, and creative collaboration. We thank Robert Bates and Robbert Flick for their significant support of our ideas and for the project as it developed over time. We are indebted to Cathie Brettschneider, without whose skill and persistence as an editor this project would never have resulted in a book. We are also very grateful to the College of Arts and Sciences and to the College of Architecture and Urban Studies at Virginia Tech for generously supporting this project at many stages. We are grateful to Hamilton College for its support. We are appreciative of the Art Museum of Western Virginia for mounting an exhibition of the photographs at an early stage of the project.

Carol Burch-Brown

Trailers

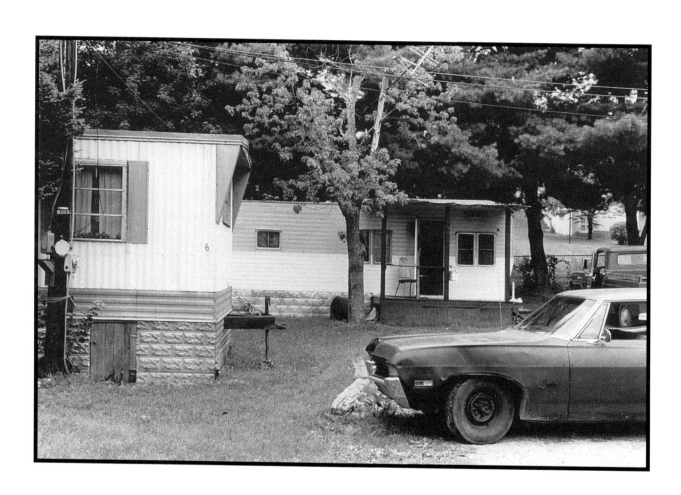

**M**y family has a trailer at the beach where we frequently go to

revive and sometimes repair the damage of thought and thoughtless-

ness. Logistics permitting, we will also celebrate birthdays, anniversa-

ries, or holidays there. We will most especially also go there to manifest

a whim, whether that means simply vacating the home scene when

the quotidian reaches a certain frenzied pitch, or more positively, when

the prospect of experiencing the alternating scale between the cell-like

solitude and the vastness of the Atlantic seems to be no more than

a good idea. For many years we held a family reunion there every

Memorial Day, with upwards of forty relatives representing four gen-

erations swarming down from the motel to the two trailers (the other

belonging to my aunt), until my grandparents grew too feeble to make

the two-hour car ride to the beach and the tradition lost its celebratory

focus. One summer when I was newly postdivorce, emotionally pre-

carious, and apprehensive, I went there to spend some time beyond

the summoning power of telephones and mail. Immediately I found

myself listening instead to the distant but incessant violence of the

surf, which I had the temerity to describe in a poem written at the time as "gnostic"—meaning, it would seem, that the wave-action embodied a cyclic motion of launching forward and returning—a fact true enough of waves, less so of people, in whom the description's application actually rested. For all that, the appearance of trailer-gnosticism was *apropos* the placing of boxes beside the shore, where the noise of the surf pounding up the beach bounced off the tin walls outside, and that very pounding, though it was merely the ambient nature of any coast, became a metaphor: the violence carried forward by the sound became, in turn, contained *by* the sound. The waves, it seemed, suited my thoughts. For recreation, I read Enid Starkie's biographies of Rimbaud and Baudelaire. Perhaps I was trying to discover if my lassitude was connected, not with defeat, but with the poet's *ennui,* for I was despondent, living through my own sea-adrift. Only the impersonal confines of a tin house, so obedient to the decree of right angularity, could have held me together until my natural resources began to reassert themselves.

In my mood of subtraction, I had left the car at home, and sometimes I would climb on a bicycle and ride up the state road past

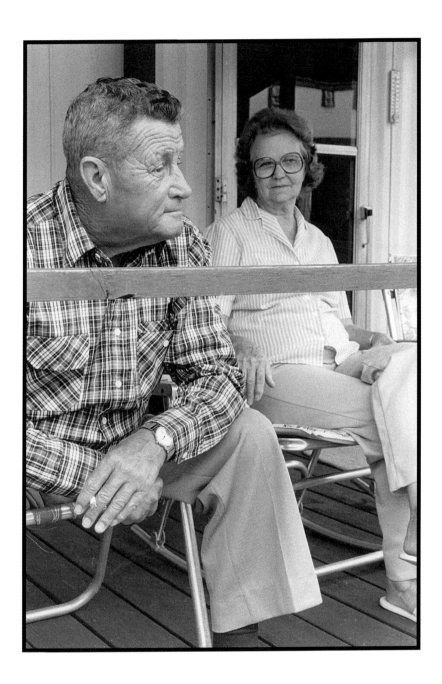

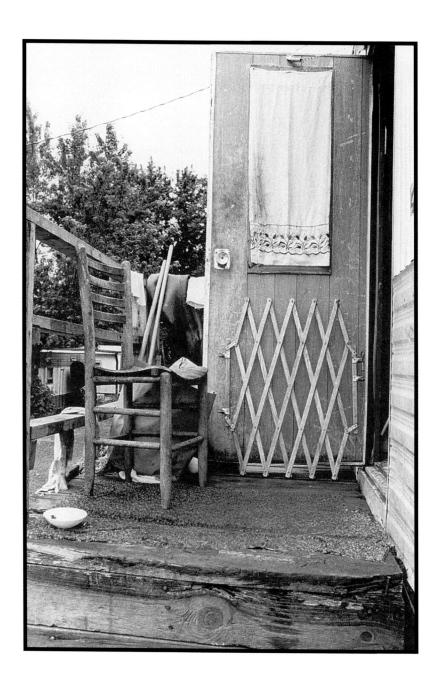

the other trailers that sat in the sun like a display of toaster ovens, even the meanest of these rigorously air-conditioned and hermetically sealed. At night, their simple windows revealed the blue glow of TV screens. This was the second, miniature azure, trophies captured and displayed after sunset. It was a quiet parody of a neighborhood, and we were quiet parodies of neighbors—some of us, of people.

But I don't mean to be cutting: this scaled-back society took the form of a benign parody familiar to all vacationers who carry symbols, talismans, and souvenirs of their belongings with them into the vacation zone, as if to domesticate even the cleared spaces of repose. I differed in my wish to subtract these very symbols, but after a week I was of course glad for the TV and the snowy countenance of Johnny Carson, as well as for the other household amenities with which my parents had invested the place. The paradox of the neighbor's seeming fullness versus my seeming depletion was, of course, easily resolved: irrespective of amenities, we had all submitted ourselves to the steadying discipline of containment.

Cutting a low architectural profile, the trailers were like the figures in aerial photos: flat and diagrammatic. Thus, anything—a tree,

a telephone pole—seemed capable of rising above them with ease. Some, virtually hidden in the low brush and swept branches of yaupon trees, looked like jungle tree houses, as though evolution had taken a U-turn—or less grandly, only as though time had rewound to the place where tree houses seemed a logical delight—except that of course they were on the ground. Occasionally an enterprising vacationer would build a deck atop the facility, though doing so brought only a modest increase in the view and no escape whatsoever from the biting insect pests that emerged nightly from the nearby swamp. The land along the beach was flat, so it didn't take a tower to give the impression of aerial advantage, the ship's hopefully vigilant crow's nest, though one rarely spotted any sentries lashed to the mast.

The moon would stand at the end of a long road that led to the ocean. At night, like others in the small seasonal town, I would gather the family fishing gear and head down the road to the island's community focus, the fishing pier. This pier, its parking lot lined with trailers and RVs, performed the duties of a social outlet, only in this case, one couldn't resist the sneaking impression that the outlet was metaphysical, too. People came from all over the state, hunkered down in their trailers by day, and at night, swarmed out onto the pier, as if

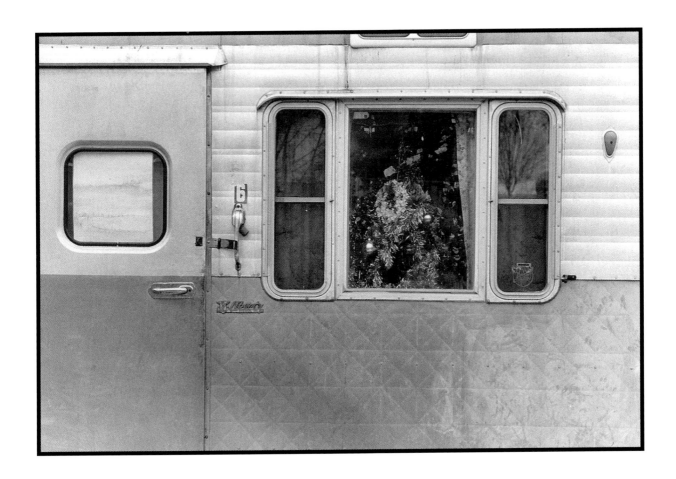

they expected a destination beyond, or as if some desire for a beyond were being satisfied by this bridge, which didn't end, didn't carry over, but, as it were, trailed off into ellipsis. Its importance in this respect seemed tied to the increased concentration of trailers there. They seemed drawn together in a magnetized jumble, as if vectoring for the push into another dimension.

And why not? Looking down at the water that seemed especially heavy and consequential in the moonlight, one could see pale creatures gliding past: stingrays and mantas, occasionally a shark of considerable size. Truly, these were creatures worthy of any moon's *influenza*. Meanwhile, swimming among them were the fish prized by local anglers—blues, croakers, spots, and flounder—fish whose very names suggested deteriorating states that the trailers, from which we had emerged and to which we would retreat, seemed destined to help us avoid or contain. Some nights there was no wind, and you could see the blue curl of cigarette smoke unfolding and italicizing the presence and wistful repose of someone over the calm water. Whole families with prodigious amounts of camping equipment would stream from their trailers and set up on the pier, as if they were refugees preparing

to undertake a border crossing. But there was only the water and the moon. Without feeling the need to relinquish any of its clichés, the moon rose formally in its mysterious beyond and let down its spidery filaments until they touched the water's surface, then fanned out in a wavy corridor. Although the moon alone might have seemed sufficient for the fancifully inclined, no one lost sight of the practical objective: catching fish. Most nights were punctuated by intervals during which the ambient level of activity was spurred to a state of arousal, for schools of fish would swim by, and lines would whiz all up and down the pier, followed by the taut, reverse snap, indicating a strike. On those nights our coolers took on a melancholy gravity, as we packed them steadily with fish still stiffly twitching, their mouths breathing what Elizabeth Bishop called "the terrible oxygen," their startled, waxed eyes all fading nerve and glycerin. The return was necessarily more encumbered than the setting out, and we would leave the iced coolers at the trailer door, save the cleaning for the next morning.

One summer a few years ago, my aunt had a stroke in her trailer and, within a few weeks, died. Of course, there was no telephone, and as a

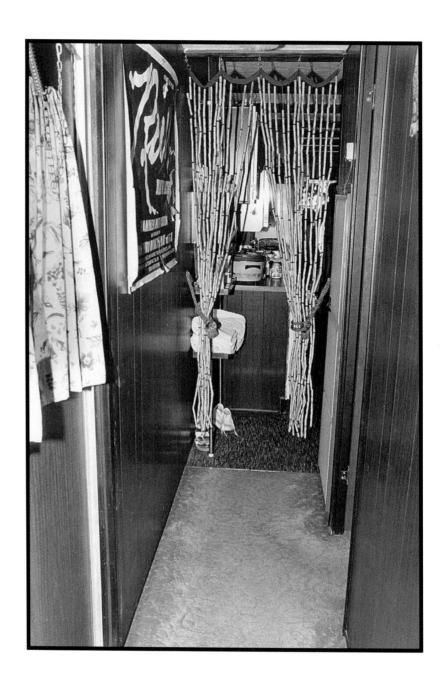

result, she was unable to call for rescue. The feeling of self-sufficiency in trailers is such that, not only does a telephone represent the world's intrusion, but other devices related to the security of standard homes (sentry systems, smoke alarms, even thermometers) are often excluded, as well—and not even excluded consciously, but simply omitted as irksome or inappropriate, if they're considered at all. Since one does not prepare for the arrival of death in a trailer, my aunt had, for her more modest needs, relied on a public phone on the corner of her block. She consoled herself with the thought that, since her trailer's lot bounded a convenience store parking area, there would be plenty of people to call upon in the event of an emergency. As it turned out, my parents merely happened by and, getting no answer to their knock, let themselves in—an easy trick, since my aunt rarely saw reason to leave the door locked, anyway. They discovered her lying on the floor, wall-eyed, incoherent, her clothes soaked. Like all true vacation dwellings, her trailer was unfortunately and agonizingly remote from the hum of city services, and the critical time frame was compromised further by the refusal of the first hospital they found to treat her, though she was clearly in perilous condition. They spent a frightful night riding the dark

highways in pathetic quest of a hospital that would take her. Her legacy, if it can be called that, consisted in her survivor's knowledge that she had, at least, spent her last happy hours in her beloved trailer. The same kind of knowledge surfaced some years later, when her brother, an avid sport fisherman, died on the pier, a cerebral hemorrhage taking him out "as he would have wanted to go."

My aunt, whose brand of optimism was typified in her remark that she had always managed to keep a skip ahead, as the devil nipped at her heels, had forked over a life's savings representing years of grim self-stinting to acquire her trailer. Indeed, she loved it with all the human love that can be summoned on behalf of a thing, for its importance in her eyes far exceeded its value as housing: it was transcendence itself at the end of a scrappy life. After my aunt's "accident," as it came to be known, it was necessary for her brothers and sisters to sell the trailer quickly to secure her a place in a nursing home, where she languished and, finally, failed.

My aunt came to represent the ill-starred branch of my mother's side of the family, and the luck of this branch was never good, early or late. Be that as it may, families are more flexible than

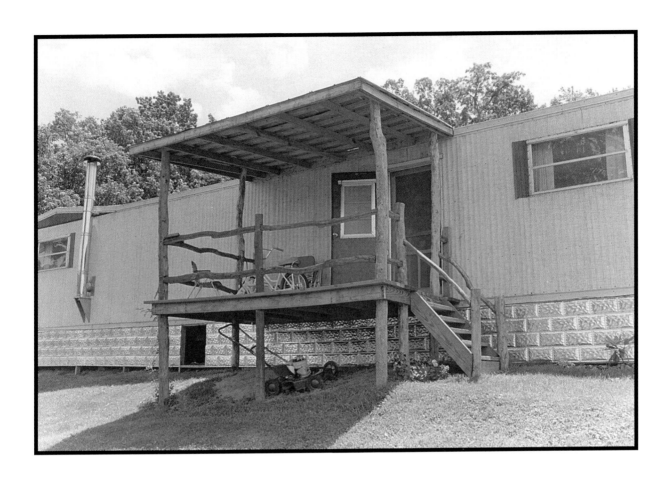

trees, and the history of bad luck is finally a matter for students of schadenfreude, not chroniclers of the gritty lives of actual people, let alone connoisseurs of trailers. She had married, for example, an unassuming, slump-shouldered man whose wardrobe apparently consisted only of overalls, one of the little men who populate the darker warrens of Faulkner's landscape. He was a master of the taciturn, particularly when he attached himself, as he so often seemed to do, as my grandfather's—his father-in-law's—shadow. I suspected that he had few thoughts important or public enough to push to the doors of speech: he simply existed, neither affable nor unfriendly—the very categories seemed somehow not to apply. His laconic ways would not have provoked anyone's notice had it not been for his expansive wife, to whom he stood in austere contrast. Unable to earn a decent living, he consigned his wife and the one offspring they proved capable of producing, a son, to life in a drafty, unpainted, unsightly, dilapidated clapboard shack that bespoke a poverty almost inconceivable in its blankness. In comparison to this state of affairs any trailer, as it confidently dealt with the southern climate's harsher rays and as it testified to the justice of geometry in the midst of nature, would have, ipso

facto, seemed to demonstrate something equivalent to the existence of a Higher Being. My aunt arrived at her elevated estimation of trailers simply by moving in the diametrically opposite direction from the one where the house of her marriage and family life stood and fell like a ruin at the end of the dirt road. He, meanwhile, contracted Lou Gehrig's Disease, and his subsequent long, wretched slide into oblivion sucked the little means they had after it. Their son, like his mother, also had a story in which a trailer figures prominently and, in his case, posthumously. In keeping with the general luck of his family, it was not a happy story.

My cousin had not fully recovered from the Asian flu when he put back on his baseball mitt and, without further ado, brusquely crumpled into permanent paralysis. Meanwhile, not only did his physical condition go from straight to crooked, but his constitution went from rosy to embittered. His mother had invested in him all her dreams of escape, and in her eyes, this escape would take place as a result of his education, to which she had persuaded him to harness his considerable intelligence. It was all planned. He understood the only escape from maturing into another nonentity lay with the state university,

where, from the age of five or six, he had set his sights. But with the

multivalent malfunctions brought on by the polio, he saw his 1950s

dreams of becoming an engineer slowly and completely withdrawn

from his grasp. After all, he had observed the campus of the state uni-

versity for months on end from the perspective of hospital beds, where

he had undergone numerous painful and, in retrospect, useless treat-

ments. Nevertheless, in time he recovered part of his composure—

enough to attend, briefly, the local community college, but he never

restarted the motor of academic ambition. Maturity sets most of us

straight about the myths and surrounding rhetoric of childhood ideals,

and my cousin seems to have come to the realization that he was fated

to be a crippled, undereducated country boy. Unable to countermand

that fate, he did the next best thing: succumbed to its *amor fati.* He

remained in his colorful but redneck county, surrounded by acquain-

tances who required no special explanations or arrangements to accept

his jerky, laborious approach. Socially recycled, he became a dispatcher

for the local emergency squad. Within a few years, he had moved into

a trailer, married a local girl, produced a family, and grown a spade-

like, patriarchal beard. One day, as he sat before his dispatcher's micro-

phone and switchboard, and apparently with no other warning, he slumped over and toppled from his chair, expiring on the spot of a cerebral hemorrhage, an offering to the chaotic god of his own wracked brain. He was thirty-seven. With his death, the mortgage on his trailer was paid off, and his wife and two children picked up the pieces and slogged on.

Almost a year later to the day, a late November storm front cut its way through the South with Sherman-like efficiency. A spectacular system of zinc clouds marched across the sky in stern phalanxes, trailing multiple tornadoes and capable of devastating whole towns, particularly towns that because of their indigenous poverty weren't bolted securely enough to their earth. My cousin's widow had gone out under the menacing green sky looking for her daughters, who were returning from school. Almost as soon as she had moved a hundred yards from the trailer, a funnel cloud descended from the sky and touched down here and there, as if knowingly, like an elephant's trunk extended over a fence. By the time it reached her trailer, it had vacuumed up enough substance to be transformed into a kind of club. With indifferent efficiency, it smashed the trailer from its cinder block foundation. The steel

bands securing the trailer to stakes popped loose, aluminum panels flew like barrel staves, and the trailer was knocked, spinning, half a mile away. Her spine snapped, my cousin's widow had awakened in the cradling branches of a pine tree, the dawn autumn stars twinkling through the needles. In this chaos and in the aftermath, she did not find out until the next day that her daughters were safe.

Even before she left the hospital, there was no question that she would "rebuild." That vocabulary belonged to people in houses whose relationship to the ground beneath was different in kind from hers. In the days following, neighbors had been able to point to the heroic walls still identifiably intact, though relocated, a roof peeled back like a canned ham, but still loyally attached, and at least at the original site—as in fires—a vestigial foundation of cinder blocks. By contrast, neighbors with traditional houses were able to show the effects of a contrasting philosophy, namely, that although their houses were likewise savaged, their surer anchoring had enabled them to achieve a goal far nobler than that of their poorer trailer relatives: it kept them from sliding, skipping, or flying over the surface of a suddenly unpredictable and slippery earth. In other words, it kept them

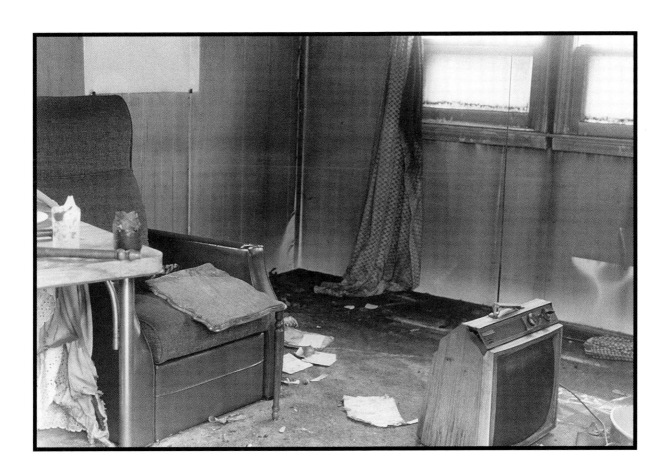

from the horror of hellish transport. Achieving such a goal confirmed the older, conservative wisdom that offering ways to stand up to the elements was what a house, in the last analysis, ought to do. It was a promise no mobile home could proffer.

Yet it would be hard for anyone with a southern agrarian background, as I have, to not warm at some point to the idea of trailers. They are empirical facts in our lives, just as they are in the lives of those we designate, in the bucolic parlance of the region, "kinfolk." They are no longer strange as the successors to those unpainted clapboard farmhouses that have sheltered (albeit with depressing minimalism) families we have known and that have heretofore been such potent images in the South's iconography. Trailers have established their own familiarity, which is that of understated contrast. They are visually laconic, just as, mutatis mutandis, many of their inhabitants practice a potent economy of verbal understatement. The effect of this understatement is to create a bond, an affiliation whose members encode as much with what they do not say as with what they do. Unlike with most species of housing, the rhetoric of trailers creates cognoscenti.

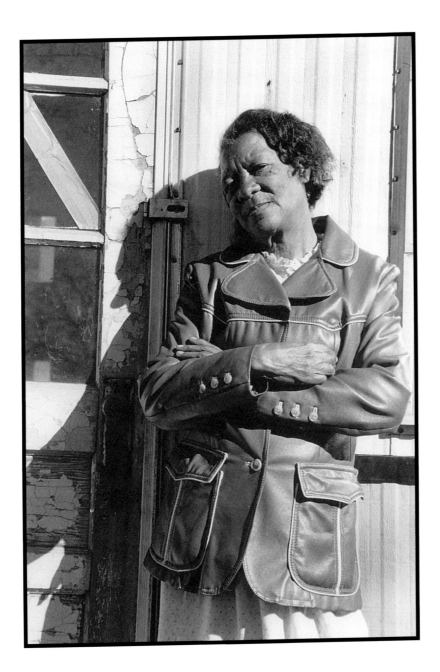

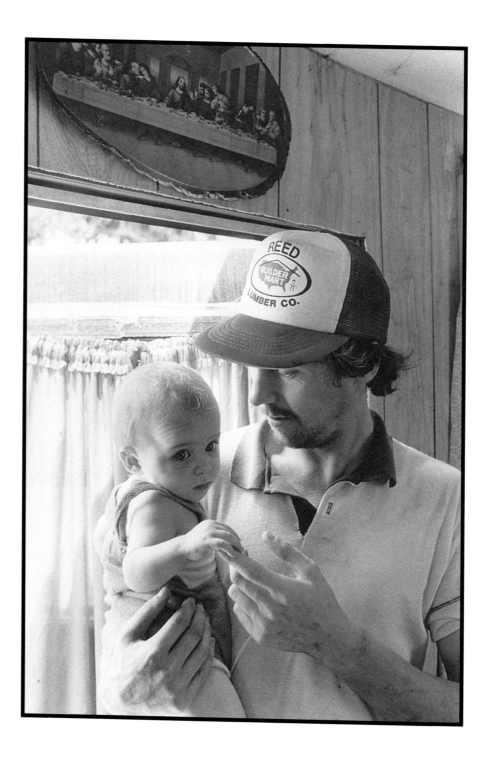

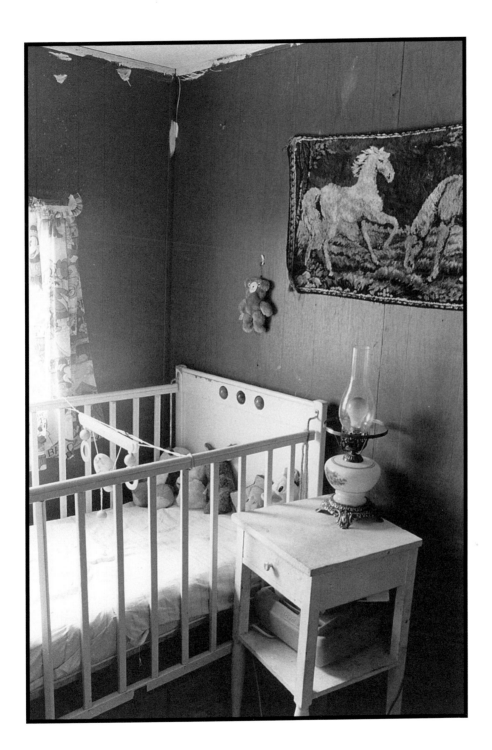

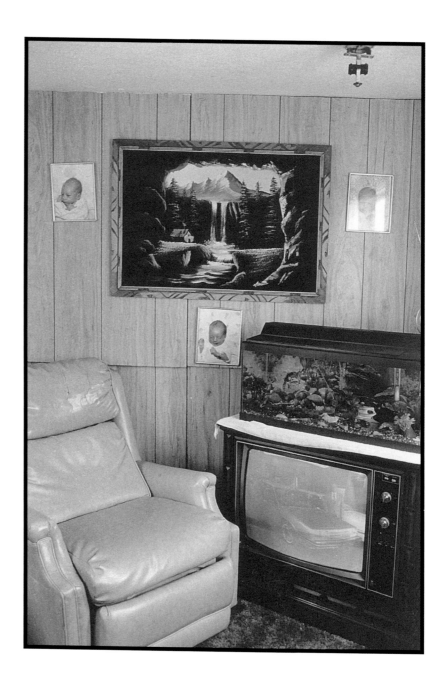

24

Not only have mobile homes become conspicuous features in the landscape of the South, they have, more importantly, become a part of its culture. I think nothing, for example, of the fact that several of my cousins have lived and reared families in mobile homes. However, to contemporaries of my parents' generation, this fact would be a sure sign that they had lost caste (unless, of course, the mobile homes were in some way temporary—say, a first house). Nor did it seem in the peculiar that my brother, before his unforeseen suicide two years ago, had purchased a sizable trailer, where he spent virtually every weekend and vacation with what scant serenity (as we are now beginning to understand) he was able to muster. But he was not forced by circumstance to live there, and it is not inconceivable that the trailer became his hermitage from his secret, metaphysical storms, before the inevitable and devastating end. Be that as it may, he was firm, explicit, when he said he *preferred* the time he spent in those close confines to the time he spent in his opulent condominium situated in the snow-flattened, plains-intimating tracts of northern Ohio. I like to imagine that he was serene, plunging his hands up to the wrist in that tiny basin of water, thinking not of inferiority or loss, but of only the cleans-

ing feel of water. And when the summer creatures contributed their homely racket after the raw Ohio winter had scraped the last vestige of cheer from the landscape—as James Wright saw and raised to the status of a singularly American lamentation—I like to imagine him walking outside and running his hand along the warm aluminum siding before returning to his carapace.

In spite of the chasm that opened so recently upon the *horror vacui* and pitiful elusiveness of our foundations and bonds, my father is heard to resonate the same opinion about the family vacation mobile home, which I do not doubt represents for him a Thoreauvian simplicity after forty years on the factory line, evolving from the square one of post-World War II economic beginnings to relative security in retirement. It belongs to a pleasant—or perhaps more recently, *anesthetic*—plateau, a time cleared of debris, and symbolized by the pretty, white plainness of his mobile home with its white road, edged with the luster of crushed shells, leading invitingly to the rise, beyond which the ocean emerges into view, surmounted with its optimistic caravels of cumulus. An amphibian, my father feels at home on margins and in hybrid surroundings, such as a trailer would appear to one of his generation. He

has the proprietary touch and, over the course of twenty years, has turned the family vacation trailer into something approximating a cottage, planting trees here, flagstone walkways there, pushing back the encroachments of the nearby swamp until the sandy soil has relented all around and produced a genuine lawn.

The trailer also tells the time: the appearance of the front deck coincided with my marriage and the birth of my brother's son. The side deck, reinforced, that faces the swamp, was erected by my father and his grandson on a weekend's whim the summer after the death of the latter's father. I can tell the year of every object: when the new sofa/ air-conditioner/bed appeared. I know when the Audubon poster of east-coast seabirds was hung, when the microwave arrived on its wheeled cart, when the backyard was drained and the toolshed moved into place. The year of the tree fog invasion, when the desiccated carcasses of frogs appeared by the dozen between the panes of the storm windows. The year my favorite cousin, once beautiful but now stricken with liver cancer and jaundice, had a farewell toast with my brother, my new significant other, and me at the Keatsian "Mermaid Tavern." Walking back to the trailer, we shared only her squashlike pallor in the

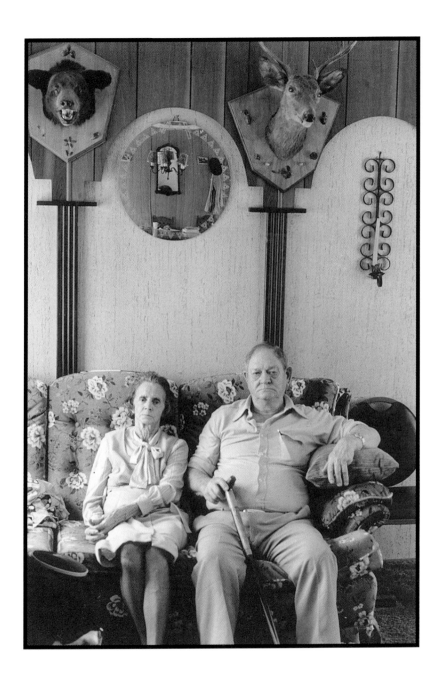

sodium light. The year of the burglary, when the TV was snatched. The year my ex-wife named the favorite rocking chair that used to contain her form ("Nelly"), which was two years before I sat down in it and read Enid Starkie. And so forth.

I too have relished, if that is not too untoward a word, the economy of correspondence that the place has provided: its concentration has been my concentration, its simple worship of Euclid, my restoration of order. It's no wonder that over the years, through the rubble of divorce and death, it has enabled me to accomplish a good deal of writing—which is to say, living—there. For what is writing but life carried on by other means? What is a trailer but exactly this?

In the interiors of trailers, one's eye will frequently fall on a seemingly irrelevant detail that, as the imagination goes to work, begins to say something important about the modal difference between trailer life and life in fixed-site homes. I remember an endless Sunday afternoon in my aunt's trailer when my optical nerve's dull surveillance came to rest on the sofa fabric. I suppose that she had acquired at least some of the furnishings with the purchase of the trailer itself because of the

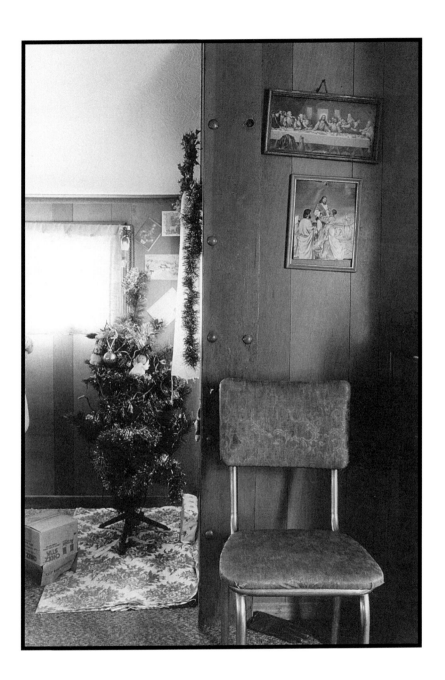

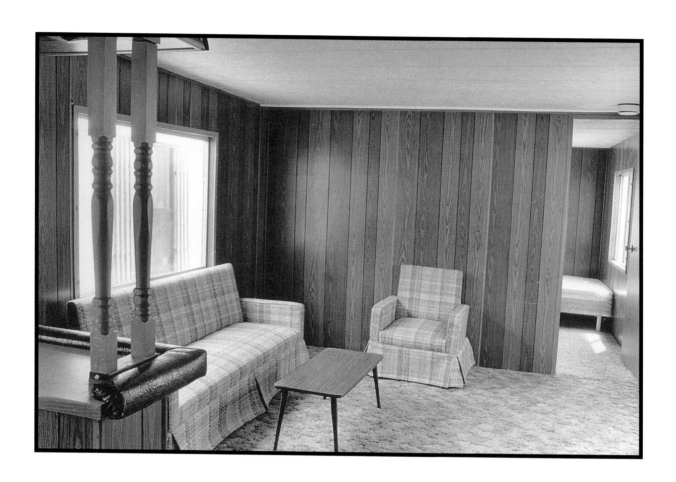

uncanny "fit" of color to decor and the cheap but substantial texture of the fabric. The three-cushion sofa was embraced by a cowl of sturdy, stained oak, and the cushions—both the main cushions and the sewn-in and button-punctuated bolsters were an anonymous plaid of brown and ochre, appealing to no aesthetic but quite prepared to acquire the smirches and spills of a mindless onslaught of occupants. It was the kind of college-inherited sofa found in the furnished basements of yuppies, a sofa that had nearly absorbed its mortal share of beer and chips. For that matter, it had likely absorbed its reassignment of status from the living room down to the rec room. It seemed to me then, as it does even now, that this kind of upholstery fabric had been created to be less an object of manufacture than an index of downwardly adjusted circumstance—like a currency released by shadowy powers and descending without complaint to find its new place in a world of speculation and shift. The meaning of furniture changes when utility supersedes comfort; the thinking behind the change doesn't eschew comfort; it only relocates it on a lower, more realistic plane.

Moreover, it was as if, in spite of the humble mission upon which the weave had been launched, the fabric had been woven by

the Fates rather than by loom operators who were merely human. One can see the three allegorical women spinning the democratic weave, spinning into the cheap, demotic cloth the promise of endurance. That rough weave would be as rugged as canvas, as rough on the skin as burlap, both of which connect the sofa to its hallowed ancestor, the covered wagon, implying a tradition, in spite of the trailer's general emphasis on the present tense. The Fates would know that the fabric, stretched and mounted on its sturdy frame, would also produce the illusion of occupancy, of alert space filled with intimations of purpose. From this, however, developed an ambivalence known to all trailer spaces: the inhabitants' need to interrupt the geometrical rigidity of the trailer's interior and the resulting visual overcrowding once the inhabitants insert themselves in their now-patterned environment. Occasionally, as though aware of the ambivalence, one banishes patterns for the blank of a plain fabric, still hemplike in its toughness. Such a substitution usually underscores durability at the expense of taste, as with the upholstery fabrics in cheap cars. But durability raised to a prerequisite creates, as everyone knows, its own aesthetic, anyway. Besides, a trailer actually lived in will almost never contribute to the impression of

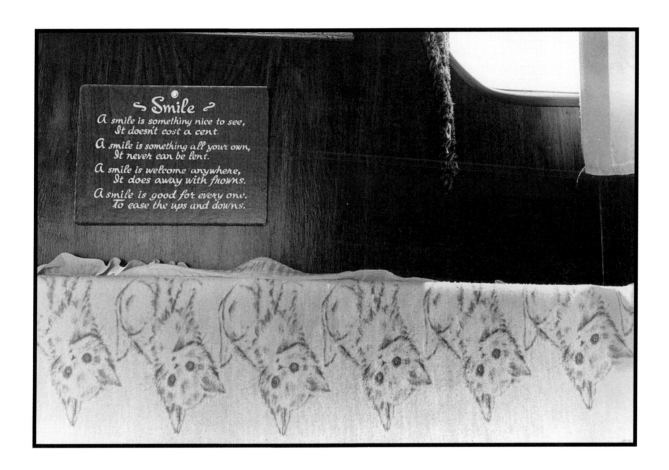

emptiness. The circumstances dictating the appearance of such hardy fabrics are not the same as those belonging to middle-class suburban life. One has to triangulate the stress of confinement with that of traffic *and* economics, for, generally, no single one of these considerations will prove decisive in and of itself. In this respect, selecting the covering of a sofa or chair becomes as highly situational an affair as paying bills when they exceed the available cash.

Which is to say, many things about trailer life are "lifelike" in their imitation of the familiar, for the excellent reason that the customary buffers, which repulse the world's harsher forces by means of a system of perimeters, are not as abundant as they would be in a house, and this fact of surprising proximity contributes to their synthetic status. These many things constitute a kind of mimicry of the normative, the status quo, and it may be said in favor of mimicry, derivation, and cliché that these nouns, unlike most nouns, have but one agenda: perpetuation of the species. They do not lose sleep over the question of origins, nor do they develop wanna-be anxiety. As far as they're concerned, it's all in the public domain. Or so it seemed—embryonically—to me that day my aunt, atop her Naugahyde barstool at

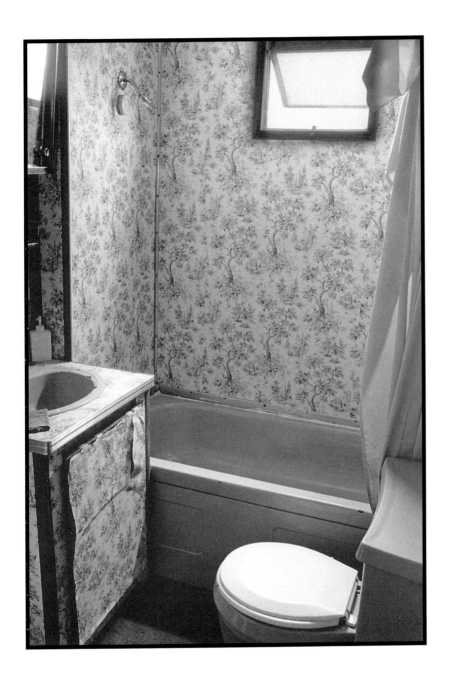

the kitchen counter area a few feet from the sofa, offered me, with a gap-toothed smile, a slice of pineapple cake.

By virtue of its sheer lack of substance, a trailer speaks eloquently to circumstance. And this in turn reflects a just apportioning of its powers of evocation and harmony with its mortal inhabitants, for the rawly circumstantial looms forever just around the corner. As in Wallace Stevens' "Anecdote of the Jar," the trailer both invites and realigns its own atmosphere, as if to remind us that, in the long run, the dominion of circumstance exceeds the sovereignty of the will, be it ever so enterprising. And yet, it is indefinite in its way, which is why the trailer's austere angles and robotic submission to the idea of encasement amount to something like the envelope's knowledge of its content: it is secret, not for general scrutiny, let alone consumption. Its closure is a seal certifying the importance of solitude and setting it over against the pressures that would turn it out. The nature of this circumstance is partly economic—it exacts a fare, certainly, but it also registers with the deeper feelings everyone has about the tenacity of life and its fixed shadow, human fragility.

The structure of a trailer provides a fit box in which to coil the

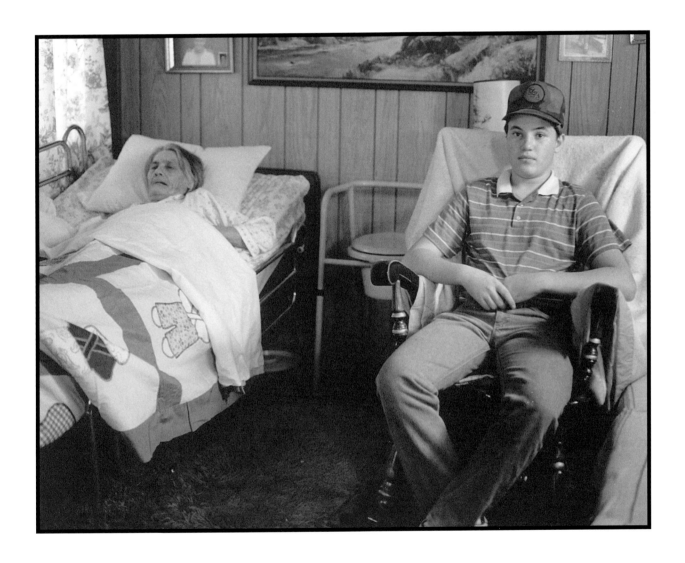

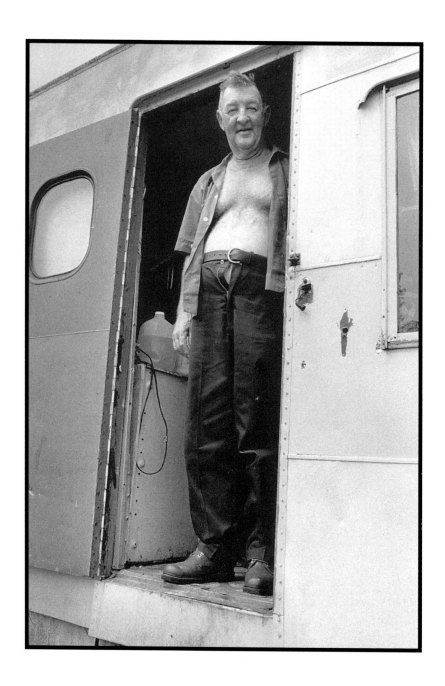

lifelines of its inhabitants. The skein comes to rest there and requires no further bunching or tightening. The snake/skein—perhaps noose—image comes to mind naturally the moment one imagines the human dotted trail setting out upon the landscape and returning at the end of the day. How, in this respect, is the structure more apt than a house's more insulated enclosure? The trailer is the transformer box that re-doubles this dotted trail and prefigures the logic of its interchange with the outside world. It is also the power box of a dream space: its de-fined enclosure induces something like the captive's fantasy that the mind to which it has access is as large as the world, to which it does not have access. The trailer is in one sense a claustrophobic fuselage to which a fellow human being brings the usual symbol-hoard, the ob-jects acquiring value as the calendar leaves (rather than the fuselage) fly, for the trailer has given up any pretense of flight, conceding instead to creep through only time. One surface backs, as it were, against outer space; the other settles against a world that, because it is spon-sored by nature, is as irrelevant and empty as outer space, if space is defined by its lack of signs. In spite of the often valiant and creative attempts to modify or otherwise conceal its eccentricity, the trailer is on

its own. And the same is true for those who emerge through its aluminum door.

The world offers us first the prospect and later the chore of mobility. Geography sees to that personally, and human desire follows with the complaint that geography unrelentingly displays its talent of placing objects, as every baby knows, mostly out of reach. Trailers, for example, perch on a hill and then proceed no further. Their cattle and other animals, if any, spread out in concentric circles, as if they knew that the authority of structures lies precisely in the fact of their immobility, in spite of their wheels and railroad car-like design. This is a chief paradox of trailers: they do not move. Of course, the smaller, recreational knockoffs trail up and down the interstates on their way to Kamp-grounds, and tornadoes are famous, not to say tiresome, in displaying their skill at spinning trailers into the air and spilling their contents like shelled peas. But truly mobile trailers are not real trailers; they belong to the tinny mélange spanning RVs and fold-down campers and Airstreams. Such oddities aside, proper trailers are famous for what they do not do (except once), as though in deferring the freedom that mobility advertises, they perpetuate, as I have suggested,

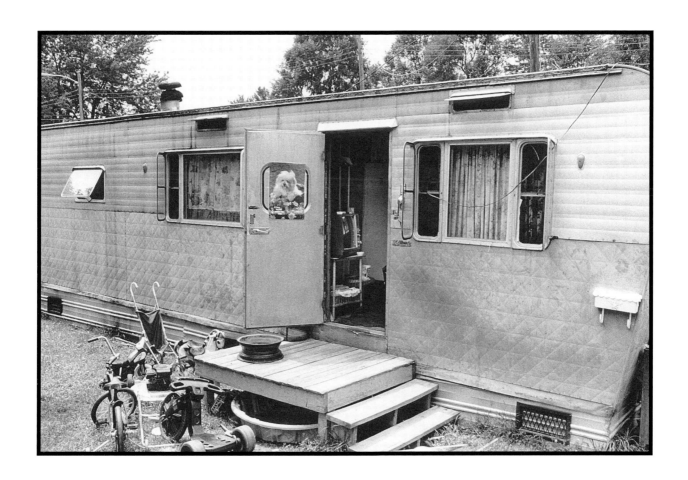

a fantasy of flight—not a fantasy that necessarily crystallizes into (even) a dream, but one that lurks in the backwaters of consciousness, prepared to move to the forefront in the shape of hope, should the need arise.

The fact of the matter is that the need arises constantly. It has already risen many times over, and it stands to rise again. More precisely, this need, like the concept to which it refers (the fantasy of flight), *stays* aloft within the consciousness the way dust raised behind a truck maintains its virtual levitation long after the truck has driven away. One wonders what prevents the dust from following, except that it is part earth, part air, part light and darkness, nothing of its own. Always borrowing, expanding, depending, devoid of any essence, it constitutes a perfect dreaming range, not the property of anyone in particular, so the air can never be said to be really clear of it. In this dust, in which we recognize the shape and dream of our need, we also recognize the image of ourselves. As the Bible asserts, without audible objection, *we* are dust. So are our creations, including structures both "mobile" and earth-bound, for indeed, since we make them from our own inadequacies, why should they fare better than we?

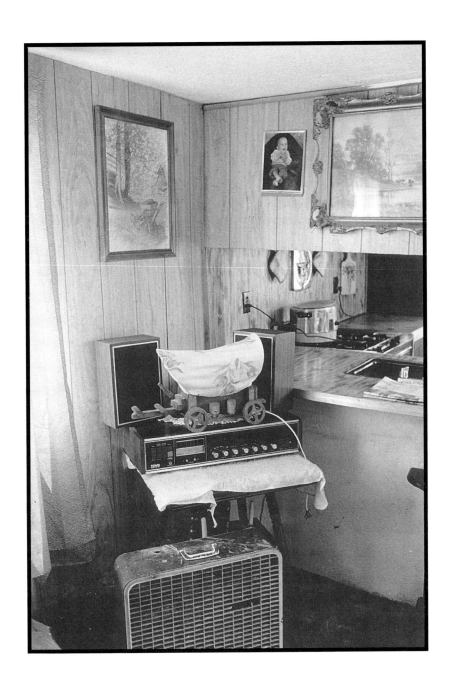

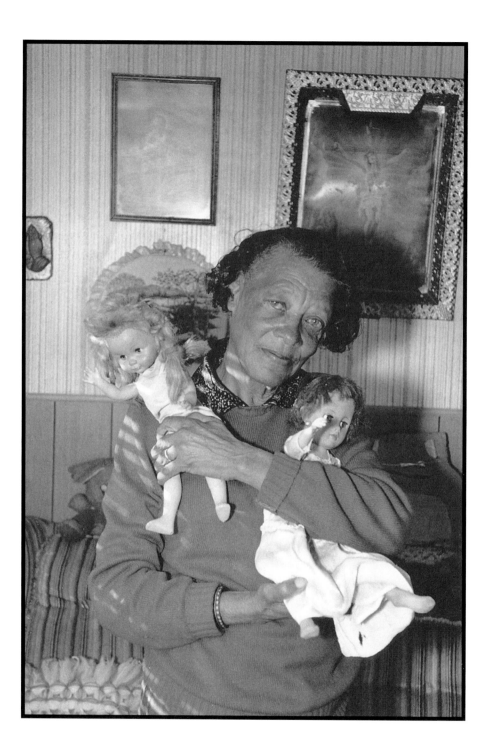

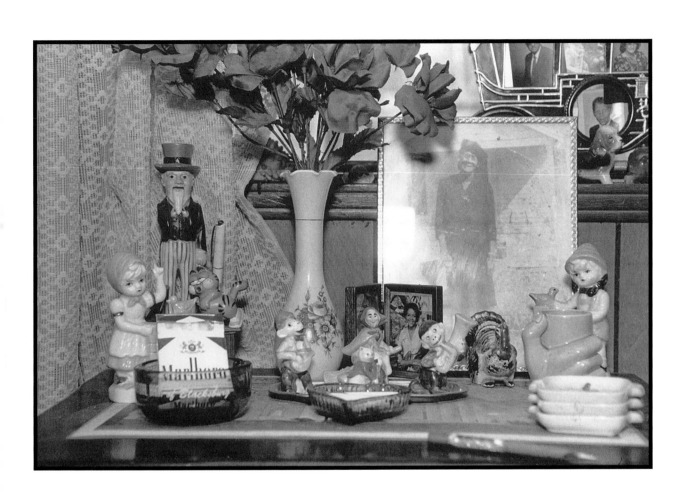

A tree's shadow falling on a mobile home will reveal an acute contrast because the surface on which the shadow rests is of a consummate flatness, with no means, as natural objects have, of dispersing the shadow's cloaking and occasionally stigmatizing impact. But the trailer as such is not in danger of being stigmatized; rather, its relentless simplicity—almost abstractly so in the purity of its lines and the formal congruity of its right angles—is endangered. The trailer's rigorous rank-and-file harmonies stand in contrast to the house's at least potentially more whimsical servitude to geometry. Houses, even tract houses, feature themselves by seeming to relish even the delicate contrasts with which they stand in relation to neighboring structures. Within the grammar of architecture, inflection depends as much on minute idiosyncrasies and innocuous distinctions as on wholesale differences. Developing potential with regard to architectural inflection does not seem to be among trailers' strategies, for in spite of their physical evolution from covered wagons to manufactured homes, trailers have stayed basically wed to the same shoe-box design as a result of their mostly unrequited capacity for mobility and their need to make the maiden voyage down highways. It doesn't

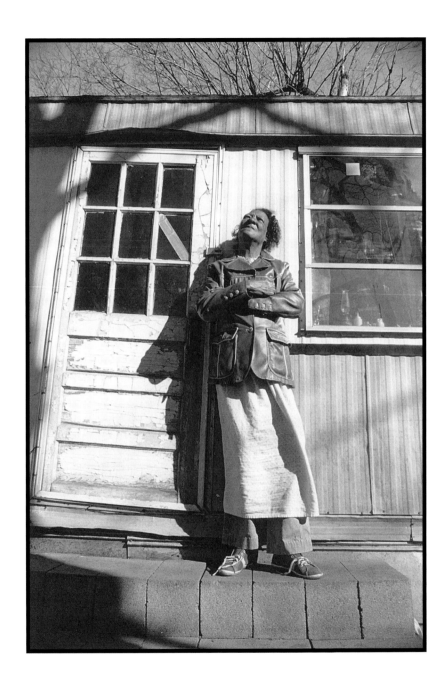

take an architect or professor of engineering to see that they have more in common visually with commercial truck trailers and railroad boxcars than with houses. This physical fact, of course, bars them from achieving much visual prestige. The shadows hint, then, that trailers are other, "unnatural" (and *unwelcome?*), and so must either reestablish themselves in some metaphorically interesting way—say, by moving closer to the idea of becoming "naturalized" within their environment—or stay bracketed and unstable within a status that doesn't apply to other single-unit houses, since these imply land and the ownership of land.

The usually doomed-to-failure attempts to naturalize mobile homes fall into three categories. The least successful of these involves the nesting of the mobile home in a natural setting itself—in a copse of trees, say, or among bushes that partially obscure it. This way is least successful for the simple reason that the contrast between the natural and artificial stands to the advantage of neither. The mobile home, in its chaste aluminum skin, emerges from its setting as precisely the exception to that which surrounds it. The shadow falls with the full force of light's absence. A second alternative is to cultivate

the grounds around the mobile home with flower beds, bushes, and trees, giving the structure the benefit of priority and, as it were, subsuming and domesticating the nature that decorates its appearance. In this way, the trailer imitates the house, whose garden and bushes, especially with a new house, exist for and at the house's pleasure. The third and perhaps the most directly "natural" way involves grafting or superimposing nature onto the trailer itself, either with the less successful addition of wood-grain paneling, or more commonly and with slightly greater success, by the addition of porches, shutters, and wooden doors. These naturalize the trailer by tying it to the same processes of aging and decay that beset frame site houses and thus serve to inject it, an impermeable metalwork object, into the cycle of living things. Unfortunately, this is also to detract from the trailer's advantage, that of the strict durability, not to say imperviousness, of its blunt exterior. There is no question that situating a trailer (if the exact spot is not already a given) becomes a vexing problem by and by. Contemporary top-end mobile homes attempt to avoid the problem altogether by imitating the facades of houses, and while there may be some tactical advantage in this procedure, such homes suffer in their turn from

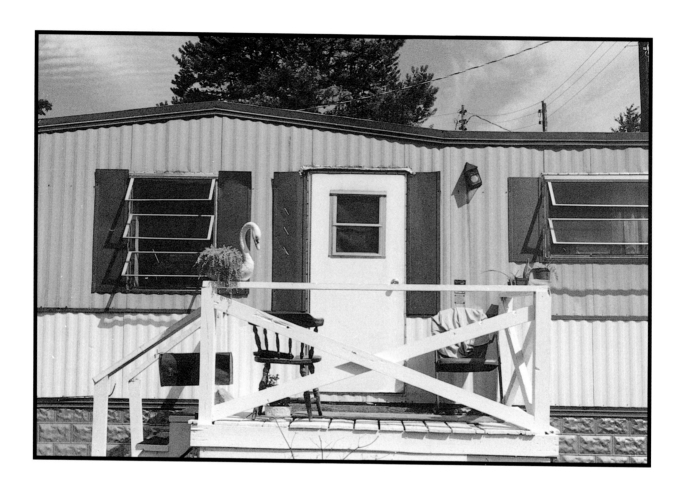

looking too much like low-end houses, instead of establishing them-
selves as the best examples of a distinct type of dwelling.

The contents of a trailer are usually very precise as to scale, and it is a
sign of luxury to be able to disregard this otherwise cardinal consider-
ation in one area or another. The kitchen area is scaled down by a
good fourth, and the bedroom furniture seems shrunken, suited to the
dimensions of a room with near walls and seven-foot ceiling. The
downsizing is perhaps most clear in the bathroom—its impish tub, its
medicine cabinet as compact as one on a yacht, discouraging hypo-
chondria. In fact, the yacht-comparison, with its implications of value-
disparity, is not facetious: for while space is at a premium, both yachts
and trailers demonstrate a kind of earnest, overriding aesthetic at work
in the scaling down of human appurtenances. As noted by Claude
Lévi-Strauss, we consumers of the visual obtain *satisfaction* from the
shrunken artifact: it boosts our stature. Unlike life, it is always some-
thing important we are bigger than, and quite aside from the obvious
gratification at having things near to hand, our pleasure increases in
proportion to our ability to manipulate space. John Ruskin, from a

century more concerned than ours with constructing and interpreting bigness, misses the boat, so to speak, in seeing a connection between the size of artifacts and their ability to brace us with their significance. One should say that the reverse is true: we find important that which, by growing smaller, invites our more particular, subtle (and predatory?) attention, even if the expressions of that attention amount to no more than gemütlichkeit.

It is not only the appurtenances that shrink to fit: decorative artifacts do the same. Hence, collections of knickknacks exfoliate from corner cabinets and tabletops with all the scaled busy-ness of Christmas tree decorations. In this—by necessity constricted—environment, objects are simply juxtaposed and, where there are not schematic groupings, little distinction will be made between old and new. A Constable-esque pastoral of cows at a watering hole will hang inches from a Kmart baby picture, fortuitously providing, it might be argued, a sequence of hope. A scale model of a covered wagon (its canvas replaced by upholstery fabric) will sit atop a compact stereo system. Sometimes an anomalous warp develops. A poster from *Heavy Metal* depicting a troglodytic warrior slaying of a dragon will be placed above

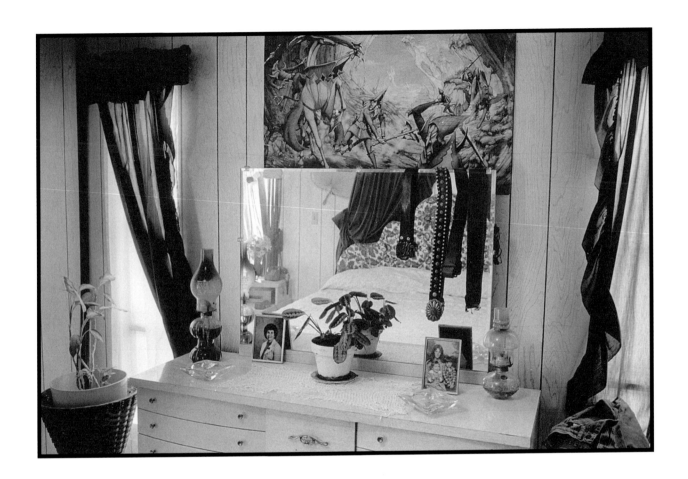

a kerosene reading lamp: futuristic retro meets American antique retro. Poet Louis Simpson observes the same apparent chaos in "The Pawn-shop," where "A revolver lying next to a camera, / violins hanging in the air like hams" strike the speaker as "Sheer insanity." But the poet knows that apparently contingent arrangements merely "cunningly" mask the deeper structure, whose function is "to appeal to someone." Thus, he wisely concludes of this wacky congeries: "Each has its place in the universe" and thereby links the material with the spiritual by means of taking note of the strategy, placement. Behind this gentle unmasking of disorder, one can hear the poet insisting that everybody belongs to *some* interpretive community. If objects abound and seem, simply by their juxtaposition, to take up the quest for aesthetics, it is no mystery to find that frames proliferate, too. In fact, by virtue of clutter, one is put in mind of the dizzying expansion of delineated space, not only by frames proper, but by the outlines of objects, which the untrained eye feels no obligation to unravel and parse into the mini-narratives they might imply. Be that as it may, each suggests, as if in a range of editorial moods, such things as the contours of the world at large and the imaginary world of wish fulfillment. For, one finds

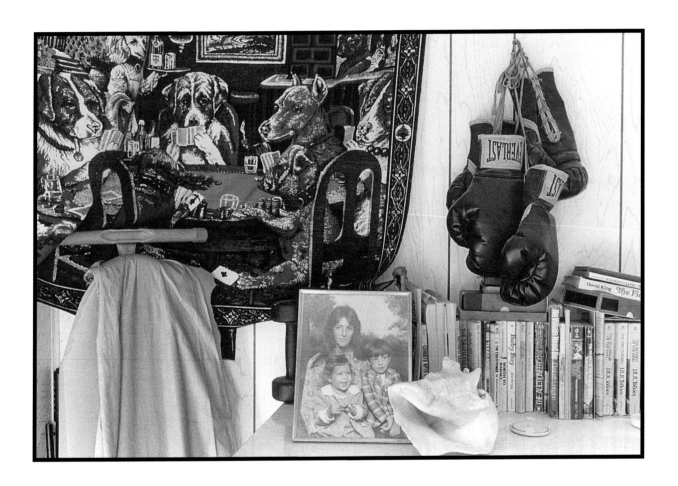

reproductions of paintings (usually of nature, fantasy, or religious scenes), in addition to family photographs, decorative plates and platters, wall hangings of dramatic or fanciful scenes, and framed mottoes revealing Stoic or thankful philosophies. One also finds televisions, mirrors, boxes, shelves, drawers, and the like, all drawn together and contributing to the governing impression of a Chinese box of infinite complexity and possibility.

Thus, it would not be wrong to say that a mobile home is a kind of dwelling that seeks to overcome the strictures of space by means of its zest for frames. One that has been lived in for some time is likely to reveal many instances of framing that make constant reference to a wider reality than just the space at hand, whether these are acknowledged by the inhabitant or not. For example, one will likely notice a proximity of frames to each other: an aquarium or a TV inside a cabinet, another TV on top of which are pictures and diplomas, a picture touching a mirror or a light. Sometimes there are superfluous frames for superfluous purposes: sconces for wall candles, suggesting a principle of redundancy, which is, finally, a principle of wealth, at work.

Because many consider a trailer to be a kind of meta- or quasi-

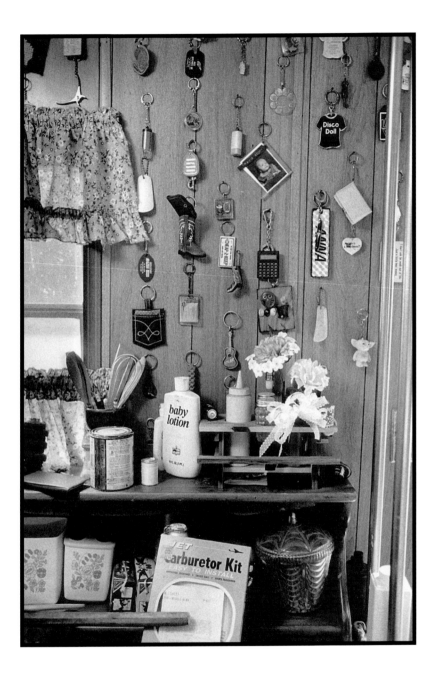

house, it is not surprising that one of its giveaway aberrancies in the eyes of the orthodox is the fact that it has no "foundation." Thus its place in the family of desirable housing is suspect on this basis alone, though the instability of its status is clinched not only from the point of view of architectural tradition, but also in terms of the domestic one, signified in trailers by the absence of lares, the household gods, whose residence is a fireplace. Although mobile home manufacturers in recent years have attempted to redress this appalling omission, there is another domestic aspect to which trailers seem relatively immune: upper stories. There are no second-story spaces, no attics filled with half-empty boxes of family relics and furniture, no personal items such as wedding dresses or retired athletic equipment. In the opposite direction, neither is there a basement for the repose of tools, dead appliances, and large outdoor gear. These must be disposed of in the available space, where they contribute to the sense of clutter, or they wind up of necessity outside, where they easily—often erroneously—suggest indifference to the sensibilities of passersby. Personal objects, then, are not subject to the same fate as in ordinary houses—that of leisurely retirement. Nor are they therefore likely to become fetishized as the objects

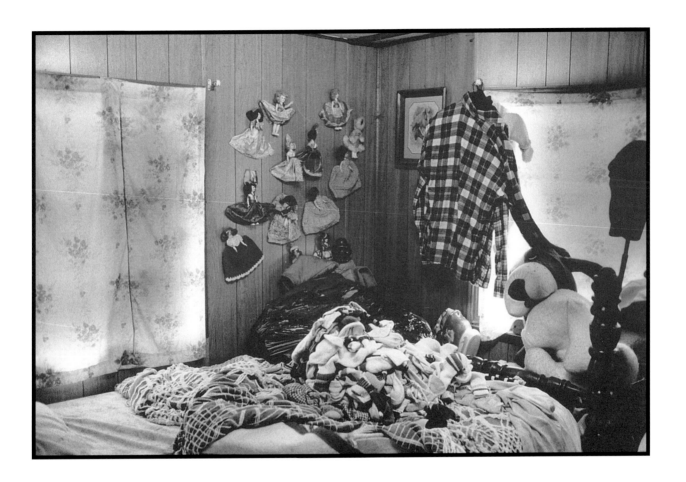

of genteel nostalgia. No one who has grown up in a mobile home can experience the same uncanny sense of recognition on discovering an attic box filled with memorabilia pertaining to the lost youth of the parents, a youth preserved among slats of light and cylinders of mote-filled air. Such memorabilia, if they exist, appear adjacent in space and time with the rest of the house's furnishings. One might say, using the late Roman Jakobson's well-known distinction, that they exist in a metonymic (that is, contiguous) relationship to the present world, rather than in a metaphorically lost, but presumably discoverable (and recoverable) one. Thus the past is not a "special" place (underlying the fact that it is not a "place" at all): it cannot deputize any present place to represent it. For that, one must go the distance and take out a mortgage on an American Dream house.

Gaston Bachelard was perhaps the most interesting modern thinker to speculate on the peculiarly psychic purposes served by houses. The floors and basements, culs-de-sac and pantries, which Bachelard sets aside as resonant sources of dreaming, do not apply when one considers the mobile home. Nevertheless, in want of such extra domains to turn into the "dream space" (a space which seems,

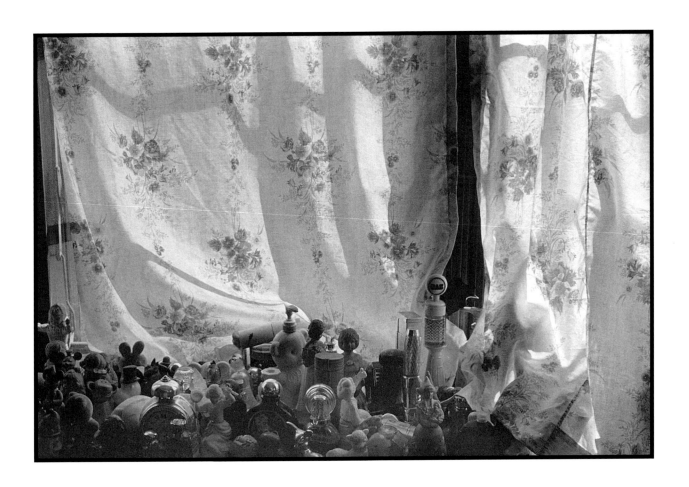

intuitively, to satisfy some psychic requirement), such spaces can be supplied in other terms—even if that means resorting, so to speak, to trompe l'oeil solutions. Framed objects, whether pictures, photos, diplomas, wallhangings, or even televisions, can take on an emblematic quality they do not possess in fixed houses, where their decorative purposes are more likely to include secondary implications of taste, class, and aspiration.

In the mobile home, the framed space "opens up" otherwise confining walls, even as it is incorporated within those walls. Hence, almost any sort of framed effect will do. It is as if, after hanging the available art, one says, "Well, then, let's try this" and begins hanging photographs, wood blocks, or mirrors (which duplicate all effects) in a messy glee. The organizing principle of like-with-like is not in danger of coming across as overdetermined, as it tends to be in large houses. The principle is, more importantly to see to it that everything that can be put up is. An ancillary to the precept is that too strict an organizing principle would damage the overall effect, inasmuch as too much emphasis on like-with-like is itself a kind of confinement.

Windows are also granted places of honor, since their contain-

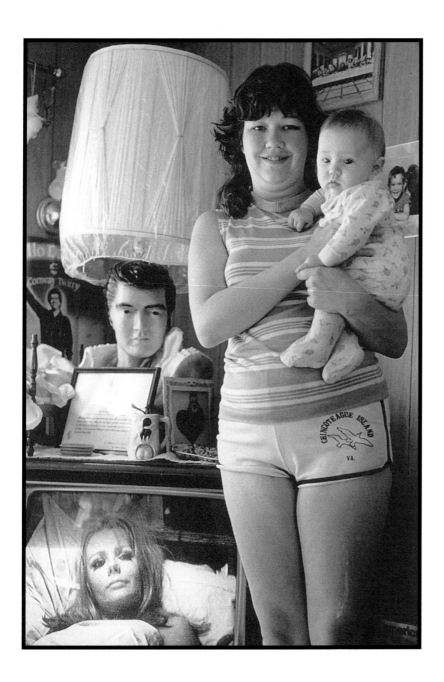

ment of the outside world stands to be proportionately more signifi-
cant than in a larger house because of the contrasting restrictions (and
their implications) on space. Francophiles of every stripe will remember
Mallarmé's numerous azure-supplicants, who love the very glass that
both radically separates them from their transcendence and regulates
it, lest its immensity overwhelm their fevered brains. Perhaps the chief
curiosity among framing devices is simply the perimeter of walls them-
selves, where one may find, for example, clusters of personal objects.
In the case of walls as frames, the representation coincides with the
entire confining panel and so has the salutary effect of momentarily
displacing the sense of constraint. Perhaps it is also the prodigal ma-
nipulation and playfulness with space where prodigality seems un-
called-for, if not impossible, that results in a paraphrase of luxury, in
the illusion of space-as-diversion, even as other, potentially more legiti-
mate claimants to the need for space go wanting.

A trailer is a product of the imagination that knows that ratio-
nal things are axiomatically good and serviceable, the way diagrams
from Diderot's *Encyclopédie,* whatever they may illustrate, include a
salute to duty. Invariably rectilinear, boxy, a trailer meets hard-angled

lives halfway, lives whose opportunities occur around spine-twisting 90-degree bends. Yet one might also see it critically as an instance of an artifact that is, by the same proportion, at odds with its environment. A trailer makes a difference of itself, for, unless one is speaking in terms of a trailer park, it is always definitively the exception to the surroundings in which it is put. Jutting from the hillside, or placed parallel to a river, the trailer's form cannot help announcing its defiance to the ad hoc curvatures and fluid vectors of nature. Its defiance also extends to and pervades the subculture of its inhabitants, whose trucks and sideburns, antiques and kitsch, do not shrink from the censorious scrutiny of middle-class eyes. On the contrary, a holistic view of trailers suggests that they are always featured in ways that subversively parody the collective, hyperbolic narcissism of mass culture, exhibiting the symptoms without, as it were, succumbing to the disease. This is a feature of subcultures in general: their ability to escape the mainline imprint while hooking willy-nilly into many of its tactics and energies. This is also their nostalgia for the lost center, the center they have rejected, but whose absence answers in the echolalic tones of a thousand country and western songs.

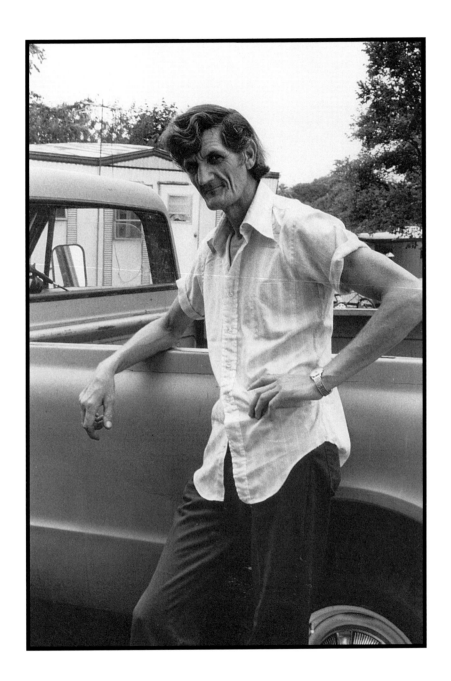

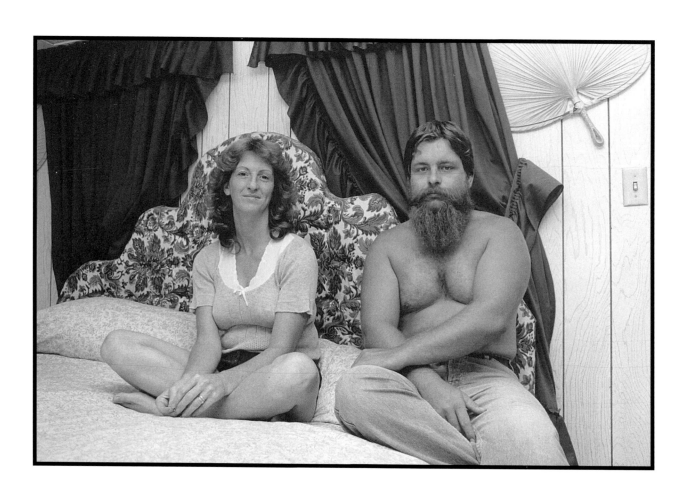

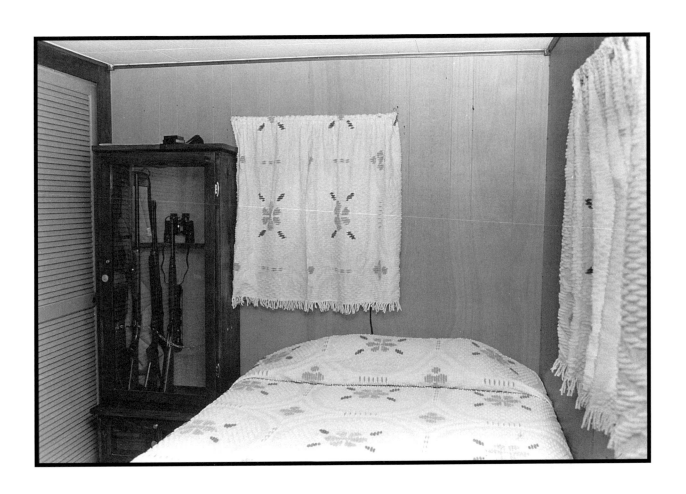

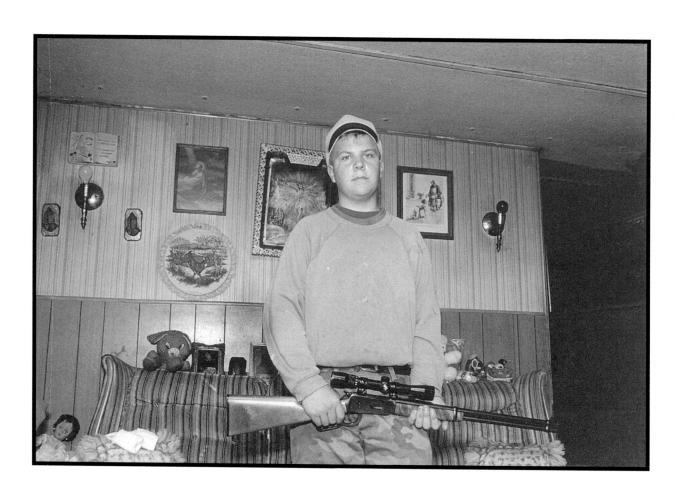

Indeed, typical scenarios invite a country and western soundtrack. And not C & W in its nakedly bathetic mode only, but accompanied by one of its frequent subtexts: spirituality. What could be less spiritual than a trailer park? Yet within a trailer park one would be grossly indifferent not to sense the nostalgia for a prelapsarian perfection. Nor would it be a reach to connect this nostalgia with religion itself, particularly in its manifestation as a vehicle for redemption. Now, it so happens that a vehicle is generally what removes us from the trailer park, just as it is what moves in both the trailer and its inhabitants. The redemptive emphasis of charismatic and fundamentalist Christianity, particularly of the free-will and Pentecostal varieties, will find a ready flock in trailer parks, where both vehicles and references to religion abound.

In a typical scenario, the patriarch dies and his farm goes to one of his children, who may or may not have the wherewithal to manage its rigors and the competition from conglomerate farming. The other children move onto property nearby, hauling their mobile homes (bought complete with appliances, furniture, and paintings on the walls) onto its most level patch of ground, and set about the next

phase of their lives. In many alternative scenarios, the purchase of a mobile home signals a return, from the west (or east, as the case may be), from the service (what the Misfit in Flannery O'Connor's "A Good Man Is Hard to Find" presciently refers to as the "arm service"), from adventures completed and opportunities rescinded in the thousands of out-of-the-way venues offered since the 1950s. They return already chastened by the world, already wise in the shapes of its cynicism, in the metaled ways of its indifference. The purchase of a mobile home is a means of declining to allow this cynicism to spin out of control— even if, as is frequently the case, the control turns out to be only illusory. For example, one can decline any of the nagging and often protracted dealings that come with furnishing a dwelling: even with decisions on furnishings, a trailer owner has "already done that." No further consideration is necessary. The furnishings and the terms in which they are selected, produced, featured, and placed all arrive *tout compris.* Trailers are also often the dwelling of choice for retirees, who prefer a community location (read: trailer park), to the anonymity of apartment life. The communitarian advantage often takes precedence over more obvious considerations, such as lower cost and easy main-

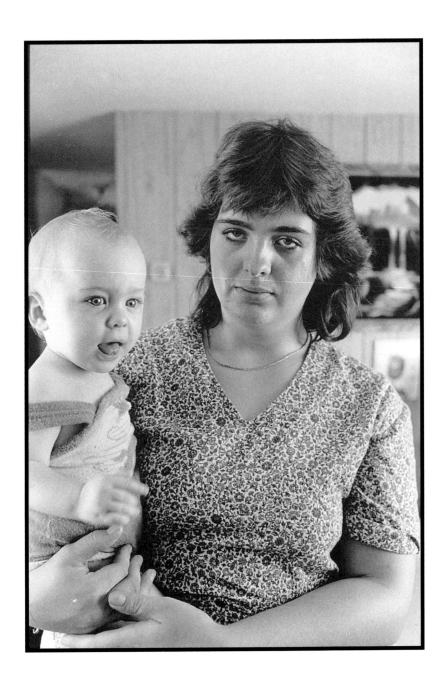

tenance, even in comparison with the very comparable value in this respect for apartments and condos. As large houses recede into fortresses impregnable to incursion and liability, and apartment hives sponsor summer camp-like "activities" to divert the unwary from stumbling upon the iron laws of the tenant-landlord connection, it may be that trailer parks offer one of the last authentic venues for the communitarian heart.

The home's "mobility" exists to fulfill another part of the Dream: that part of our Emersonian legacy is an awareness of our inheritance—as Americans—of space rather than time. To this way of thinking, one has a perfect right to maintain that a "normal" house belongs, again in Emersonian terms, to *tradition,* with all its associations of the past's claims upon the living, and as such a house represents allegiance with the past, ancestors, and placedness. The mobile home (*home,* not *house*) avoids all that. Emerson argued that the liberation of American energies could only be accomplished by severing our ties to tradition, which at any rate wasn't ours to begin with—that is to say, by abolishing our ties to the dead, that which chains us to historical time. In this, he was reformulating the terms of a famous

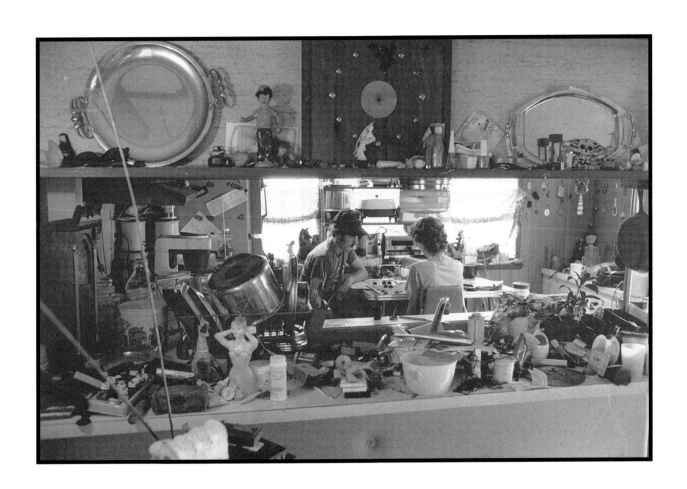

debate between Thomas Paine and Edmund Burke concerning the meaning and value of the American Revolution's first international gift: the French Revolution. Paine, straight from his own fame as a revolutionary fellow-traveler, had argued for the right of people to reject the claims of the past on the present, which, from his perspective, amounted to the blind obedience, even love, of the living toward the dead, a kind of historical necrophilia. Burke, who saw the strength of tradition from his own vantage as a comfortable Englishman, countered that such a breaking of the chain was tantamount to chaos and bespoke an arrogance of the benighted living to which all of history stood in glaring contradiction. Emerson's solution, as useful as it was novel, was to switch dimensions: time was to be exchanged for space, which manifests itself in the present tense, preparing the way both for the American emphasis on the immediate and on mobility as a "right." He also accomplished, almost as a byproduct, the bizarre task of turning time into a commodity. Thus, with the Sage of Concord's inferred blessing, one might even venture to say that the mobile home is a more authentic American house than a fixed abode. The mobile home contains the potential for establishing itself in space, that is to say,

geography, in much the same way that a house establishes itself in one place over time.

Yet the more one thinks in spatial rather than temporal terms, the more one is likely to reflect on a mobile home's relation to precipitous, rather than eroding forces. For people living in the trailer park, the options presented by the seemingly ubiquitous occasions for natural destruction are either replacement or flight. The first option involves an assumption of insurance, and insurance companies have over the years become increasingly reluctant to offer coverage for mobile homes, in response to the simple fact that the shelter they provide does not suit them for the extremes of weather they can be subjected to in a given year. Hurricane Hugo provides a case in point: trailer owners in three states were notified of cancellations shortly after they filed their claims. If the first option didn't work, there was the second, and today even small rural southern towns, agricultural marketplaces, really, have become belted with apartment complexes serviced by nearby shopping centers. They suggest, if not supply, the next exigent step in the evolution of shelter. In spite of the usual flimsiness of their construction, they at least offer the illusion that vertical buildings, by

virtue of the increase in mass, are stronger than discrete units like mobile homes. No doubt the future contains hurricanes and tornadoes eager to test this supposition. It is not certain that the move from the horizontal arrangement of the trailer park to the vertical rearrangement of the apartment building is a step forward in terms of community: people who live in apartments frequently reveal a suspicion of their neighbors, and they are therefore well-suited in this regard in their progress toward anonymity. But it is entirely possible that swapping ownership for rented peace of mind does produce in some sense a real human gain, for to own is always to possess the possibility of trouble, whereas the maintenance contract of the renter has the denominator of wind and rain covered. Such a move is analogous to de Tocqueville's observation that people soon tire of the right to deal with hardship; they would rather empower a landlord and call it a day.

In *Camera Lucida*, Roland Barthes asked, "What is a face, if not a designation?" The faces that one associates with trailers are of this type: a claim has been made on their presentations. What these claims are have to do with hard existential times and striving, or with the relinquishing of the individual's counterclaim toward establishing

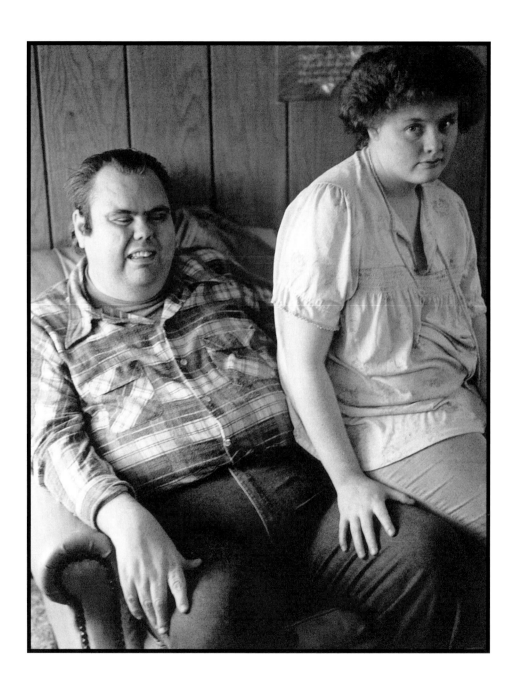

an individual look, in favor of a more generic, which is to say more serviceable, one. After all, it is life, not oneself, that dictates the shopping choice to be Kmart and Wal-Mart: why should faces, which surmount the very clothes one buys, not be preened according to the same practical philosophy? And yet our enormous vanity frequently leaves us incapable of perceiving the smaller distinctions in look and attitude that would be instantly recognizable among denizens of the trailer park. It is in the differential between the theme, however "generic," and the variation that esthetic qualities arise. Photography, by arresting the eye's hustling inattention, brings this beauty forward for our appreciation. Hence, so many family portraits figure prominently among the significant furnishings (though all are significant) of mobile homes. Like the mobile homes themselves, which are scaled-down, stringently edited versions of houses, the inhabitants scale down the spectrum of their visual expressiveness, compressing it like poetry in order to gain the advantage of understatement, as well as the protection of a mutually understood code. A grace so small we don't recognize it is nonetheless a grace, and our invitation into its presence may depend on something as ironic as a photographic image by showing us

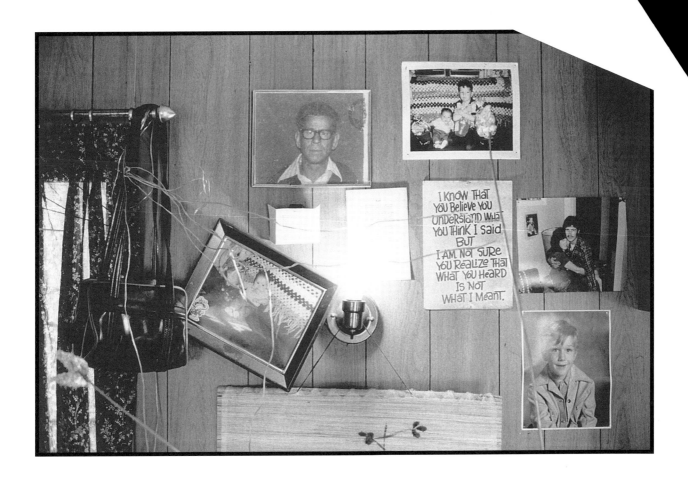

what something is by showing how it is not. But this is the case with representations generally. One might just as well begin with the ubiquitous representations of the Last Supper or with the stagy, squeeze-your-eyes-out-slowly softness of calendar art—even with a lamp whose electrical fixture rises from the creamy pompadour of a ceramic Elvis.

Although the mobile home seems to reject time in favor of its potentiality over space, it too has a history, though it is of course a largely forgotten history. The first "trailer," a perhaps inevitable consequence of the appearance and general acceptance of automobiles, was manufactured by the Covered Wagon Co. of Detroit in 1929. By the middle of the Depression, the trailer was a familiar adjunct to the migrations of workers and their families, and the trailer industry, following the rerouting of the work force, was one of the fastest growing in the United States. Here too one finds an early association between trailers and "drifting." But hard times at home were not the only reason for their acceptance. During World War II, "mobile homes," as they were rechristened, again demonstrated their usefulness as quick, low-cost housing for workers engaged in war-related

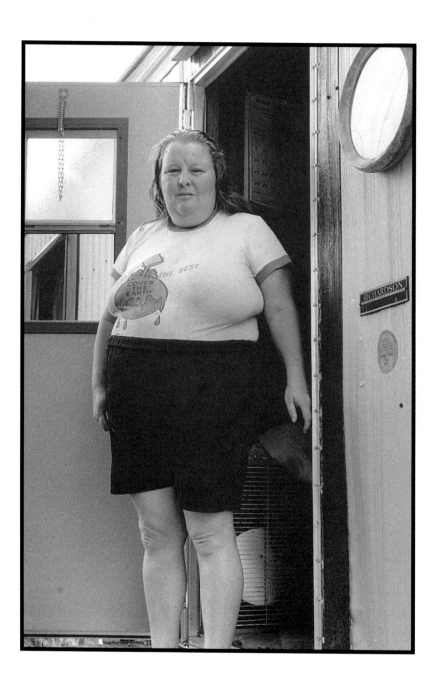

industries. Moreover, because of their "shotgun house" design (so-called, as one colorful version maintains, because one shot could demolish the contents of an entire house), they could be placed chock-a-block where lot space was limited.

The mountains of southwestern Virginia are dotted with mobile homes, that appear in three configurations: singly, as adjuncts to existing houses, and in trailer parks. Mountain people seem to favor these structures for the convenience they afford. Because of the hilly, thickly wooded terrain, mobile homes in the country repose more or less in secret until one has negotiated the hill, rounded the curve, or gone through the woods. Hence there is no need for their owners to place an undue emphasis on appearance. Nor is there need to make any other special arrangements: the same fences hold the cattle in, the same driveways lead up to them, the same picnic tables and lawn furniture surround them. They are not off-putting. At the same time, the presence of so much mobile home-life creates an image that revises a previous one about mountain people. We seem already "to know for a fact" that people in Appalachia no longer live in the porched-in, run-down shacks or log cabins of popular lore. On the contrary, many still

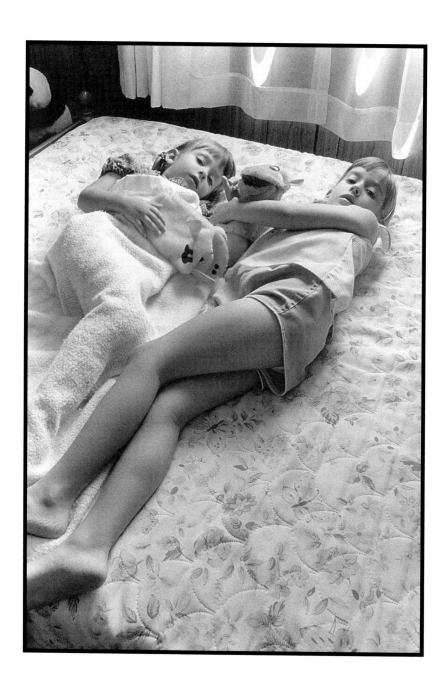

do, and this counter-fact invites speculation about the acceptance of mobile homes, both as places to live and as an image of the kind of life that goes on in the mountains. It is not at all out of the ordinary to think of life there as being conducted in and among mobile homes. They are as much expressions of upward mobility, so to speak, as concessions to the way things are.

Life in a trailer is certainly not bound to be unpleasant. In the first place, compared to a house, the screen separating inside from outside is greatly attenuated. One seems always on the verge of being outside, and although inclement weather may not make this the best of all possible situations, the cumulative effect is of an increased familiarity with the outside. Trailer life, with the tissue-thinness of its exclusion, necessarily brings one not only into close, but also knowing, proximity to the elements, their rhythms and pressures, from which one is ultimately (though literally by only a matter of inches) protected. The reverse is also worth bearing in mind: the forces of nature crowd in, but—except in the case of catastrophic weather—unable to establish a beachhead, are at last and decisively frustrated. Allegorists could draw a moral from this: danger and trying situations always

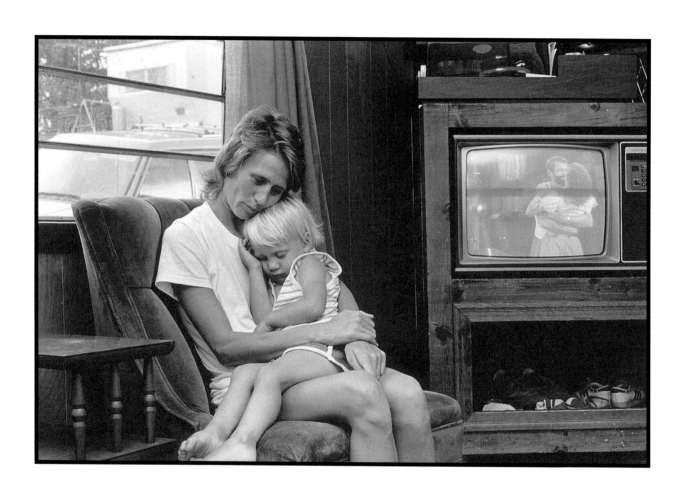

present themselves to us (after all, we are natural productions our-selves, subject to the same laws of light and leaf, rain and inevitable ruin), but moment by moment we best the external forces, all the while recognizing their war on our bodies, even as we reject these claims in a thousand battles. This kind of recognition, which the ancients must have experienced, can scarcely be said to be the experi-ence of modern-day house-dwellers. But the thin panels that hold nature at bay excel in doing precisely that: holding. As with the blue jay in James Wright's poem, "Two Hangovers," who springs up and down in a tree while a troubled, hungover man looks on, he is forced to trust the integrity of creation (and in turn our own creations) until even the trust becomes "second nature."

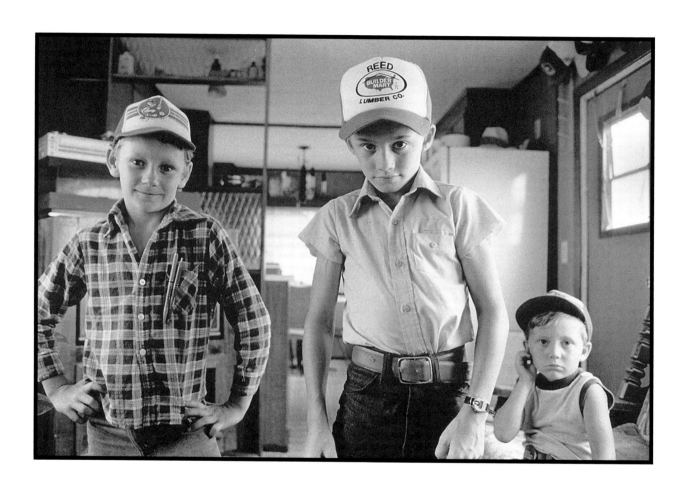

These photographs were taken between 1983 and 1990 in Montgomery County, Virginia. All the subjects kindly granted permission for me to use their photographs for publication and exhibition.

—Carol Burch-Brown